D1111986

Oil Pastel
Step by Step

by Nathan Rohlander

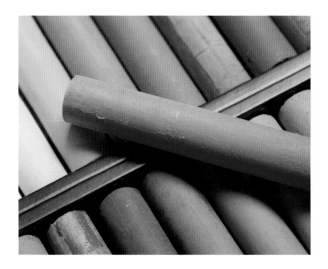

www.walterfoster.com
Walter Foster Publishing, Inc.
3 Wrigley, Suite A
Irvine, CA 92618

Project Editor: Merrie Destefano • Designer: Shelley Baugh • Production Artist: Debbie Aiken

1 3 5 7 9 10 8 6 4 2

Contents

Introduction . 3

History of Oil Pastel . 4

Materials and Techniques . 6

Sunset . 8

Floral Arrangement . 12

Bedouin Camel Portrait . 18

Pasadena Bridge . 24

Portrait . 28

Wooded Road . 34

Laundry Line . 40

Perfume Bottles . 46

Water Reflections . 52

Gondola . 58

Closing Words . 64

Introduction

For the person who likes immediate gratification, oil pastel delivers. Designed to be one of the most direct forms of expression, it provides a full range of pigment in the form of individual oil crayons. Whether you label your finished oil pastel a drawing as Cézanne did, or a painting like Picasso did, one thing is clear, the fact that these art masters used this medium proves it has much to offer.

As a lover of both painting and drawing techniques, I found myself inspired to work in oil pastel. The power of line and tone, combined with color and ease of use, make this medium rewarding. I discovered that I could work linearly and texturally, or I could layer and blend. And, if I felt really bold, I could employ both techniques in the same work. Some artists use oil pastels with solvents as the first step when creating a painting, others do this in the middle of a work. Some artists use oil pastels to make studies, while others use them to create finished masterpieces.

Oil pastel travels well and it doesn't make a huge mess. It removes the middleman and puts the artist directly in control of mark-making without using a brush—in my opinion, this is one of its strongest attributes. At its finest, oil pastel is both painting and drawing, two mediums in one.

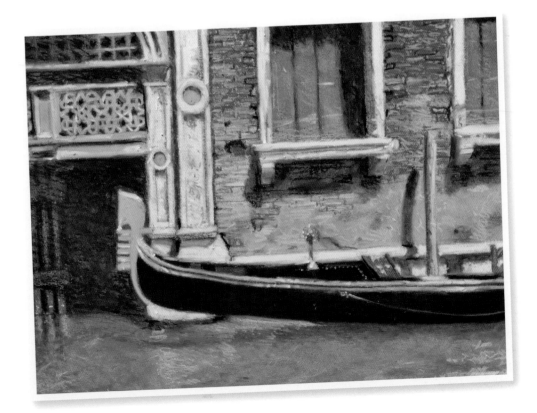

History of Oil Pastel

Breaking the Rules

When we think of mediums that relate to children and art, the crayon is one of the first that comes to mind. Creativity and expression are most evident in childhood. Pablo Picasso believed it was the artist's job to maintain that childhood creativity. He understood society's tendency to bridle youth in etiquette and rules.

It's our job to break free from those rules.

"Every child is an artist. The problem is how to remain an artist once we grow up."
—Pablo Picasso

"Drawing and color are not separate at all; in so far as you paint, you draw. The more color harmonizes, the more exact the drawing becomes."
—Paul Cézanne

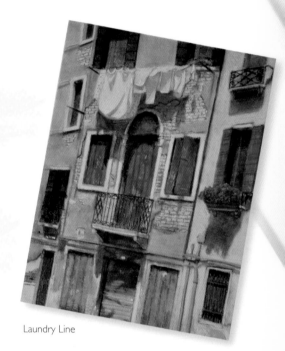

Laundry Line

Drawing Without a Master

Throughout 1912–1926, Japan experienced its Taisho period. It was during this time that theorist, author, and artist Kanae Yamamoto created his book *The Theory of Jiyu-ga*, which translates to "Drawing Without a Master." In his text, the theory is proposed that children should be more expressive with color and be free to draw.

In 1921, Rinzo Satake and Shoukou Sasaki, two brother-in-laws who were involved in education, sought new mediums of expression for their students with their new company, Sakura. With the consultation and involvement of Yamamoto they began the creation of a new crayon that was to be a combination of pigment and an oil binder. Variation in colors was important to Yamamoto's working theory of education. However, combining the attributes of drawing and painting in one tool did not come easily. It took about three years to create a good recipe for oil pastels, designed for use on just about any surface. They developed Cray-Pas oil pastels, the first to hit the market created primarily for children. "Cray" stands for the simplicity of a crayon and "Pas" for the depth and color saturation of dry pastel.

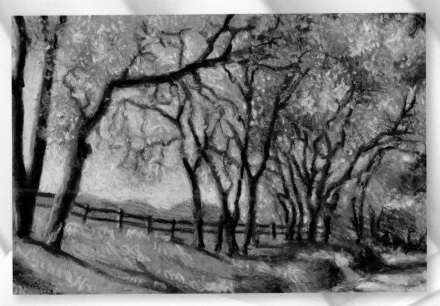

Wooded Road

Artistic Vision

In Paris, Picasso became aware of this new medium and its versatility. In 1949, he had his friend and fellow artist, Henri Goetz, approach Gustave Sennelier about creating an oil pastel for the professional artist. In 1887, Sennelier opened an art store in Paris that is still a world renowned producer of art materials.

Although Sakura's Cray-Pas oil pastels were the first, many companies now make oil pastels. They have been perfected over the years by a variety of venders. Used by numerous artists, it's truly a wonderful medium that combines drawing and painting in one gratifying vessel. Cray-Pas oil pastels were used to create the images in this book. However, no matter what brand you choose, you will learn to love creating your own masterpieces with oil pastels.

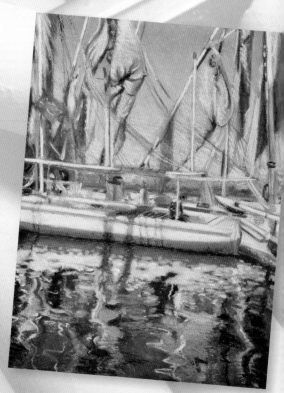

Water Reflections

Materials and Techniques

To begin working with oil pastels, you'll need a few basic supplies, listed below. While there are a number of techniques that can be achieved with this medium, the basics are shown here.

- Graphite pencils
- Conte black pencil
- Kneaded eraser
- Paper
- Heavy rag
- Gamsol
- Gesso
- Oil pastels: Vandyke brown, Prussian blue, gray, yellow, yellow orange, brown, white, black, pink, ultramarine blue, yellow ocher, olive brown, yellow green, vermillion, deep green, pale orange, green, Prussian blue, orange, lemon yellow, red, pale blue, cobalt blue, gray green, green gray, olive gray, and purple
- Acrylic paints: Ultramarine blue, burnt sienna, yellow ocher
- Matte medium
- Palette knife
- Ruler (to tear down paper to size)

Setting Up a Studio I use both a tabletop easel and a drawing board when working with oil pastels because this medium allows you to work on almost any table or surface. In my studio, for example, I set up my supplies on a converted Craftsman workbench. A good studio also needs fresh air and great light.

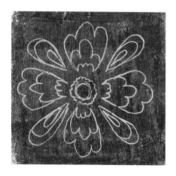

Scraping Back First put down a layer of color. (In this instance, I used yellow green.) Next, smudge this until it becomes a solid. Then, layer another color on top of it— here I used cobalt blue—and smudge it until it becomes a solid. Now, you can scrape detail back into your piece. I used a penny nail to carve through the top layer of color to reveal the yellow green beneath.

Blending With Oil Pastel Begin by covering one area with yellow. Next, add a layer of vermillion hue next to the yellow. Then, press hard and blend with the oil pastel crayon, using pressure in the middle where the two colors meet.

Crosshatching Crosshatching is a series of perpendicular lines layered on top of one another. Using a gray oil pastel, crosshatch a value and opacity shift. Pressure increases the saturation of pigment. This process can be used to both blend and gradate color.

Stippling Start with pale blue. Create an even tone by making dots over the entire surface. Next, begin on one side and stipple Prussian blue until you've made a gradual value shift like shown in the example.

Draw Back Into Begin by cross-hatching an even layer of color with orange. Next, use a Conte or Derwent® black pencil to draw on top of the orange, thus creating detail. You can also do this with graphite.

Smudge With Finger Put down an even layer of purple. On top of that, place a layer of yellow ocher, and then smudge/blend with your finger. Strive for even color.

Highlight A highlight is the chunk of light that is the lightest spot on your image. After creating your rendering, place the highlight appropriately. This grape was created with vermillion hue as a middle tone, Prussian blue for the shadow shape, and white for the highlight. The background is an even layer of yellow ocher with thick white on top.

Blending With Turpentine First, crosshatch a layer of green. Then, layer an even color application of lemon yellow on top. Finally, blend with a large flat brush, using a little Gamsol or Turpentine to create an even color.

Acrylic Toned Base First, mix a transparent layer of Ultramarine blue and matte medium. Next, use this to cover the surface. Then, create a gradient with olive brown— the pressure of application determines intensity. Notice the difference between opacity and optical blending.

Sunset

Inspiration can be found almost anywhere. I discovered the inspiration for this drawing while traveling down the Nile River—an area filled with beautiful scenery. The arid landscape of the desert juxtaposed with the fertility of the river valley, creating a rich visual contrast. At dusk, the sun hung heavy in the sky, its warmth both melting and surrounding us, the clouds filling the air with an almost magical haze—sparse landscape, glittering water, glowing sunset.

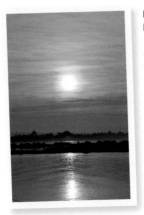

Mixing Techniques
I decided that the best way to capture this vivid image would be to incorporate some painting techniques into my drawing, using a transparent even wash along with pastel. I used both solvent and brush in some of the following steps to help even tone and color.

Color Palette

Oil pastels: Vandyke brown, Prussian blue, gray, yellow, yellow orange, brown, white, black, pink

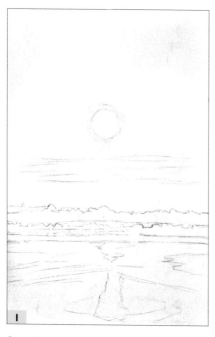

1

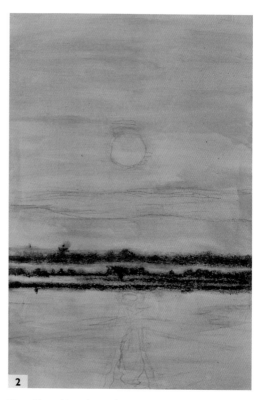

2

Step One For my first step, I make a quick rough sketch in graphite. This establishes all the major light and dark shapes like the sun, the land mass, and the reflections on the water. For this project, I used gessoed rag paper, 17.75 by 11 inches.

Step Two Next, I toned the paper with a transparent layer of matt medium and acrylic violet. This cool hue will later cause the sun to glow with warmth. If my original sketch has faded at this point, I will sometimes go back and reapply graphite to the drawing. Then, I establish my darkest darks by using Prussian blue. I vary the opacity of the pastel to create different values, and then smudge with my finger a little.

Step Three I increase my dark values by adding a layer of Vandyke brown over the Prussian blue, again smudging with my finger. Then I lightly dust the sky and water darks with Prussian blue. After dipping a large flat brush in Gamsol, I wash the Prussian blue in the sky. Then I smudge with my finger—back and forth—until I create the desired affect.

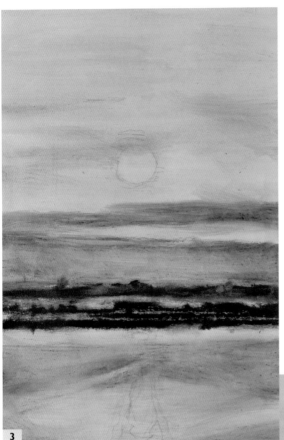

Step Four At this point, I lightly add Vandyke brown to the sky, and then blend in with my finger. If I add too much, I use a paper towel and continue to blend in, removing a little pigment at the same time.

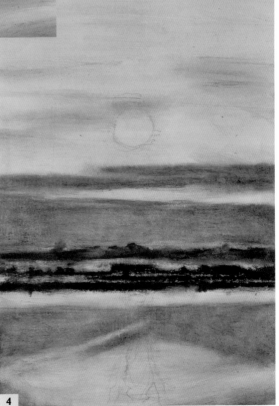

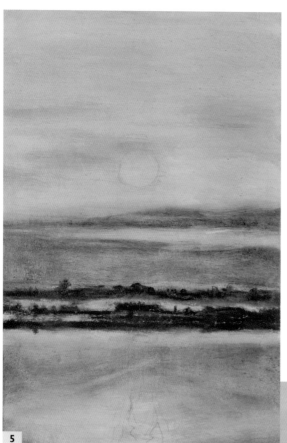

Step Five With gray, I lightly dust the light in the sky. Then with a brush dipped in gamsol, I blend in the gray. As the final part of Step Five, I take Prussian blue and add detail back into the land and trees.

5

Step Six Now I start to bring in the warm colors. I use yellow, yellow orange, and brown to warm up the sky and water.

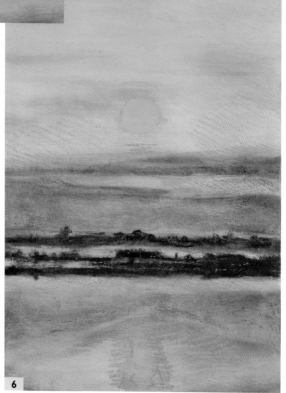

6

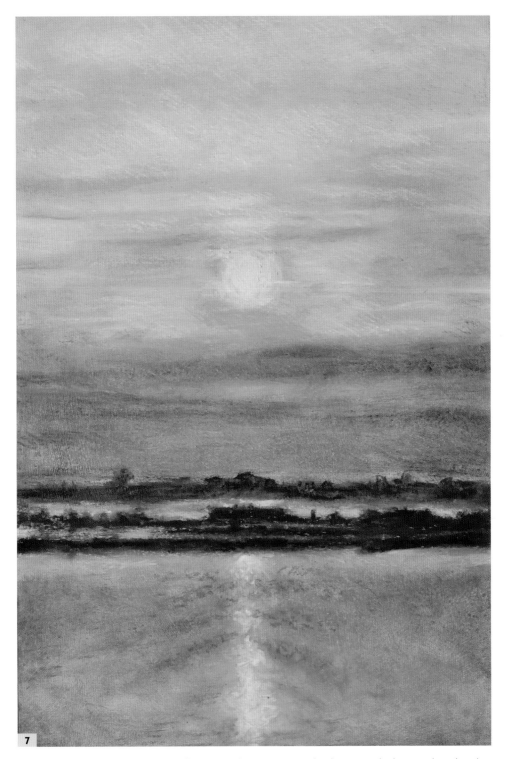

Step Seven With white, yellow, and yellow orange, I start to saturate the sky—remembering to squint as I work. I blend vigorously with my fingers and pull those lights. Next, I use a little black to darken the nearest land and trees, reinforcing an atmospheric perspective. With Vandyke brown, I then darken areas in the water and sky, as necessary. I use a little pink in the sky and water to lighten areas in the center. Finally, with white I add more light to the clouds and the top of the image.

Floral Arrangement

The floral arrangement—a time-honored and traditional subject matter—has been captured by artists throughout history. For this project, I decided to use a polychromatic palette—I felt that this would jazz up the arrangement and add a sense of energy. Tight cropping on the image filled the page with petals and updated the more traditional subject matter. The final composition reveals only a portion of the vase, thus making the flowers the focal point. Altogether, the color and the cropping work together to create a striking image.

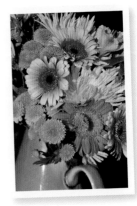

Color Palette

Matte medium; Oil pastels: Ultramarine blue, Vandyke brown, yellow ocher, olive brown, yellow green, yellow, vermillion, deep green, pale orange, green gray, white, pink, Prussian blue, orange, lemon yellow, red, and brown

In this project, I updated a traditional subject through the use of color and cropping. The vital importance of mark making and the necessity for variety, emotion, and gesture were examined as well, with the intent of breathing life into the final piece.

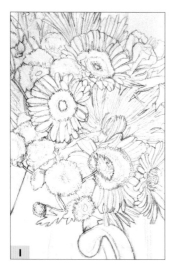

Step One I began by creating a construction drawing that defined the shapes and the flowers. At this point, variation in line weight was essential, and I used it to suggest value. I included as much detail as possible. Throughout the process, the image will become more loose, so I sought to be as specific as possible for as long as possible. For this project, I used gessoed rag paper, Reeves® BFK, 19 by 13 inches.

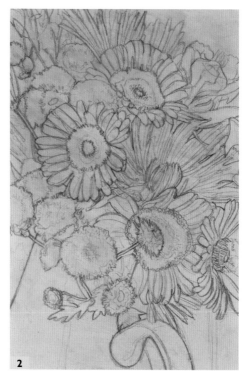

Step Two Using a workable fixative, I sealed the drawing. Then I toned the drawing with a transparent mixture of matte medium and ultramarine blue. This cool color helped the warmth of the flowers pop with each new color added. To minimize the loss of my drawing, I limited my brush work. A couple of thin transparent layers work better then a thick dark one. A gradual progression is best.

Step Three Next, I used Vandyke brown to begin my darkest darks. This helped separate and establish the figure/ground relationship.

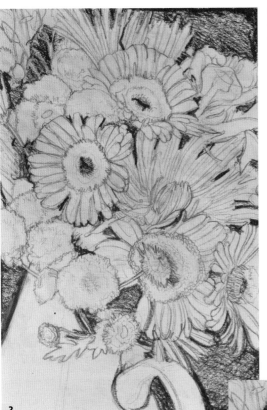

Step Four I layered Prussian blue on top of the Vandyke brown, then smudged them together. The colors blended to create a rich dark without holes or gaps that would allow the paper to show through.

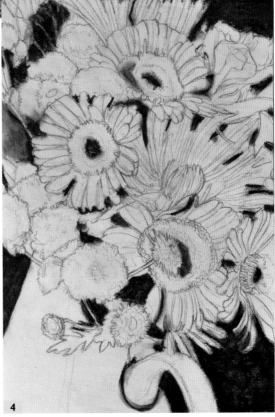

13

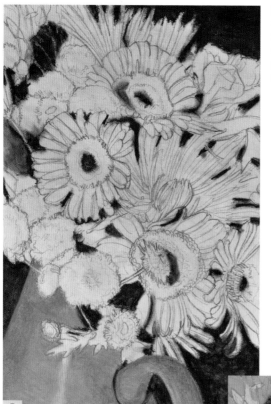

Step Five Yellow ocher was the base color for the vase. I put a layer of it all over the vase, then smudged it. Next, I used Vandyke brown for the darker areas of the vase and blended it with my finger. I then toned down the yellow ocher with a little olive brown in its brightest spots and smudged.

Step Six The green flowers were blocked in with yellow green, then smudged to close any gaps. Next, I blocked in the yellow flowers with yellow. I filled in any dark negative spaces that may have been missed in previous steps.

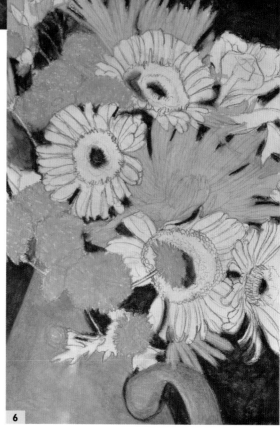

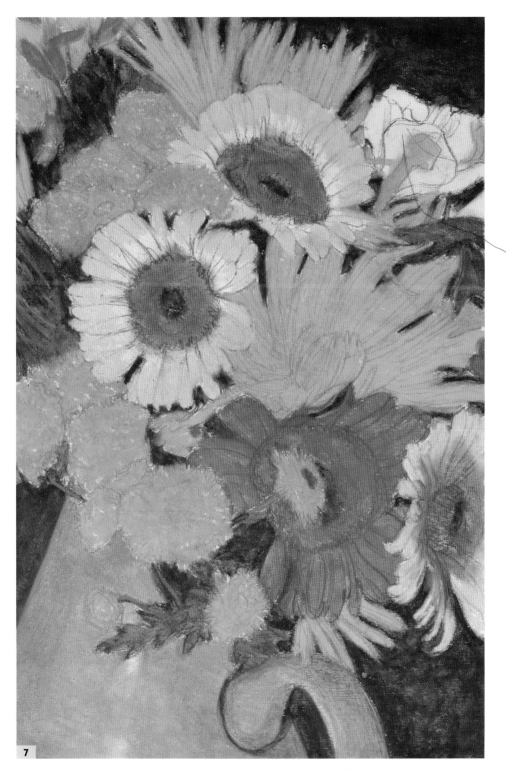

Step Seven At this point, I began to block in the reds of the flowers with vermillion, and then smudged them. The dark green leaves were done with deep green, and then smudged as well. I continued to fill in any spaces between the flowers, as mentioned in Step Six. With pale orange, I then blocked in the pinkish parts of the flowers. The grayish leaves at the top were done in green gray.

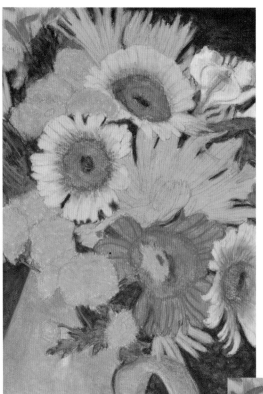

Step Eight In this step, I drew the white flower in the upper right corner, using white, yellow green, and deep green. Beginning with the white, I then layered the other colors on top. Next, I added pink on the inside of the pink flowers, following it with a layer of red on top, and finally blending with my finger. I continued using Vandyke brown to adjust the drawing and contours of the flowers.

Step Nine Next, I added detail, using white throughout to make the petals pop. With Prussian blue and Vandyke brown, I drew lines to define some of the petal contours. Pale orange was used to lighten the red flower; pink was used on the pinkish flowers. I added highlights with white. Then, to create the pollen in the big pink flowers, I stippled with orange, pink, and white.

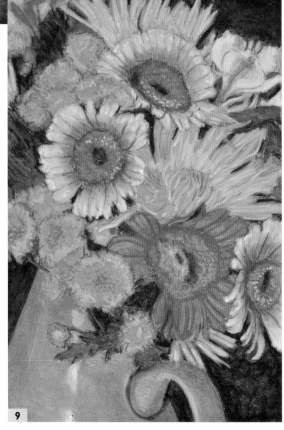

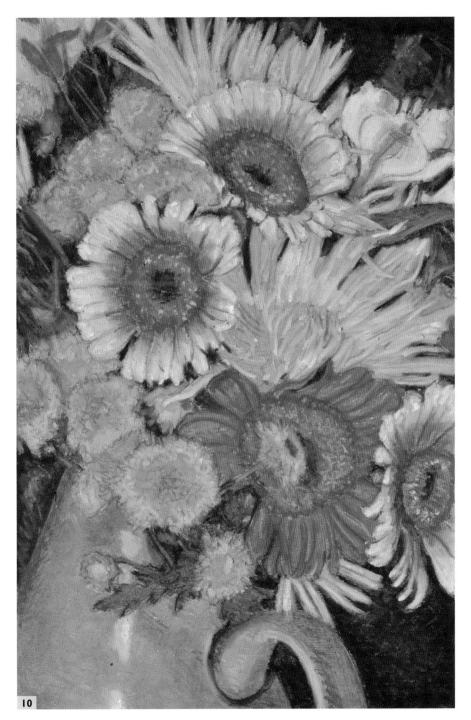

10

Step Ten The final step was the touch-up round. With green gray and yellow green, I lightened the darkest negative shapes—suggesting a little green in the shapes. I continued to create small marks in the petals using all colors as necessary, and I added white where needed. Another layer of Vandyke brown was added to the bottom right; pollen was touched up with orange. Then I lightened the green flowers with lemon yellow. This was my last chance to catch any mistakes or touch-up. With red, I lightened the shadow shape in the top pink flower, minimizing it. I touched up the vase with Vandyke brown, and I allowed my mark making to suggest texture. Finally, I used brown to separate the pollen from the petals in the pink flowers. I continued with all colors until I was satisfied with the final appearance. I made marks and pushed hard to leave chunks of oil pastel.

Bedouin Camel Portrait

Steeped in mystery and brimming with beauty, the archeological site of Petra, Jordan, is still home to a culture thousands of years old. While standing in front of the Al Khazneh, an ancient building carved out of sandstone, I found myself surrounded by the local Bedouin and their animals. It was a spectacular and magical environment, and some of the photos I took were the inspiration for this camel portrait. I was particularly enticed by the dramatic lighting and beautiful Bedouin blankets that adorned the camel. However, I soon discovered that it was difficult to capture a perfect shot with a moving target. This is why I created a composite—the merging of two different reference images to create a more appealing portrait. I used one image of the camel for the face and another for the body and surrounding environment. The exotic nature of this desert animal created a portrait that suggests adventure.

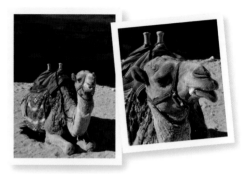

For this project, I referenced two separate photos to create one drawing. One image provided the detail for the camel face, the other provided the camel body and surrounding landscape. I also used Photoshop to isolate a particular camel from a group shot. This created a stronger composition with a central and singular focal point.

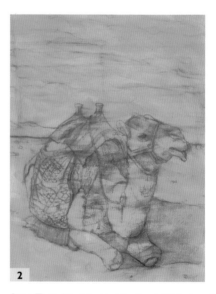

Step Two Next, I added the head. While I used the second image as a reference point—capturing the detail of the camel's facial expression—I found that I needed to make some adjustments to the background. I moved a rock that now sat in front of the camel's face, so that it didn't look like he wanted to eat it, and I raised the horizon slightly. I also used a little value to help separate the shapes and bring reason to the madness of lines. Full value isn't needed yet, for that will begin when the oil pastel is added. At this point I like to mix a transparent layer of yellow ocher acrylic paint with matte medium to seal and tone the drawing. I carefully paint over the complete image area—too much brush work will destroy the drawing. Now I have a unifying color and tone. I also now have the option to scrape back to my original sealed drawing, if desired.

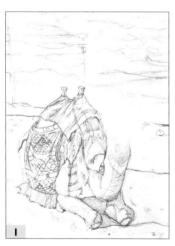

Step One For the first step, I used the reference photo with the camel body and background. I began the drawing with graphite—omitting the camel head. I focused on shape: light shapes and shadow shapes. Using a heavy, weighted line, I suggested the shadows, and with a lighter line I illustrated the lighter values. A little crosshatching can be included at this point to establish the shadows, if desired. For this project, I used gessoed rag paper, 17 by 13 inches.

Step Three For this step, I need to squint frequently while looking at my reference photo, a process that allows me to successfully determine where to mass my values. By using variation in my line weight and layering with the Vandyke brown, I now rediscover and solidify my drawing, thus establishing the dark values.

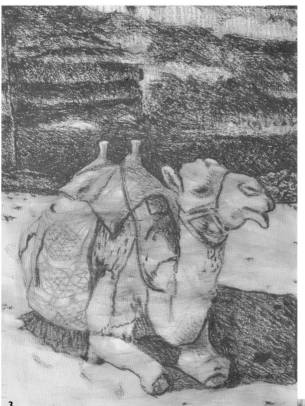

3

Step Four First, I add a light layer of yellow ocher oil pastel over the sand area, then a light layer of brown over the previous layer. Next, I blend the two colors by smudging and rubbing them with my fingertips. Taking a broken chunk of white, I use the edge to carve the beginning of a light pattern in the sand. I then blend this with my finger to create a desired affect. I also highlight a few of the stones at this point too.

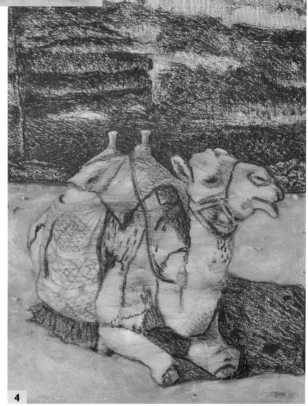

4

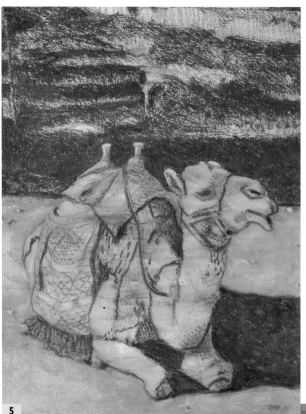

Step Five In this step, I add ultramarine blue over the previous layer of Vandyke brown. I pay particular attention to the casting shadows and darkest darks. Finally, I smudge the colors together in desired areas.

Step Six With brown, I lightly go over the top of the image and sandstone wall in the background, then smudge with my finger. Next, I use yellow ocher oil pastel to bring out the pattern in the sandstone. The same color is used to soften the shadow edges and bring light into the casting shadow of the camel. I also add some more shapes of the same color in the light areas of the sand and warm up the white from before. I then begin working on the Bedouin blanket using cobalt blue for the light blues and Prussian blue for the darker blues and shadows. After that, I fill in the triangles with Vandyke brown as needed.

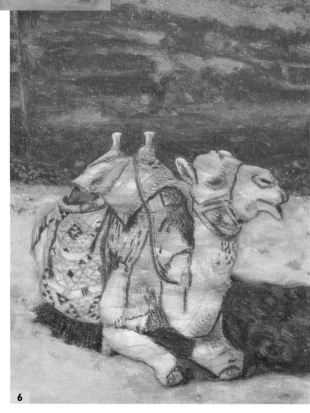

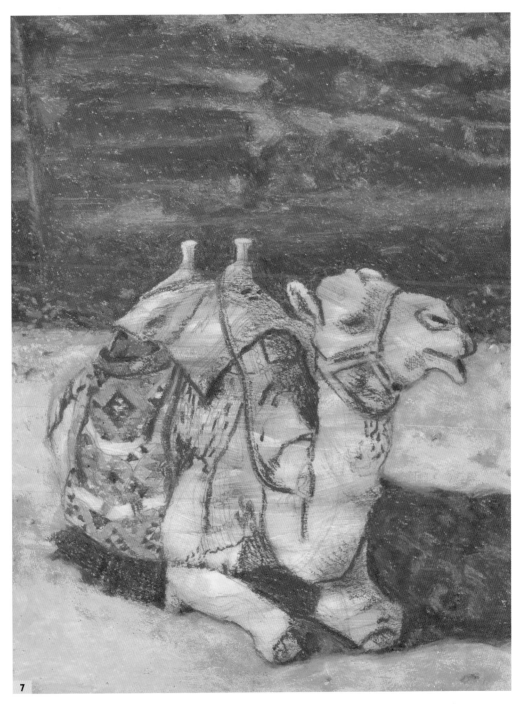

7

Step Seven I keep working on the side blanket, now adding orange, gray green and brown to the appropriate areas using a sharp edge on the oil pastel stick. If needed, I will use a blade to create sharp spots by shaving the stick.

Step Eight Now I focus on the top blanket, using red for the light areas and brown for the shadows. With white, I begin to clarify the lighter sections of both blankets. I also allow the yellow ocher under painting from Step Two to show through for richer lights.

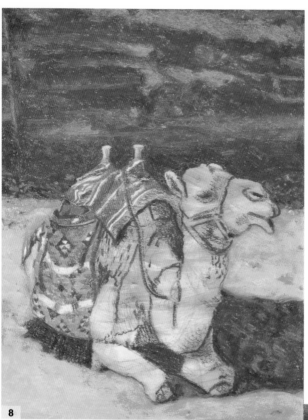

8

Step Nine With gray, brown, and Prussian blue, I jab at the paper, creating a stippled effect for the metal and straps. Using white, I then add the highlights and fill in the number 2. I lightly cover the camel hair with yellow ocher oil pastel and blend with my fingers.

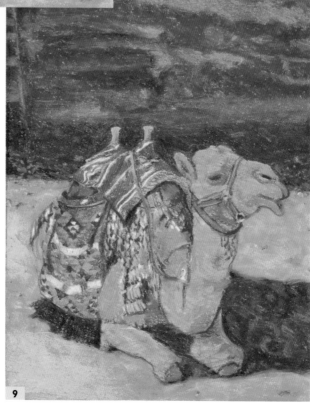

9

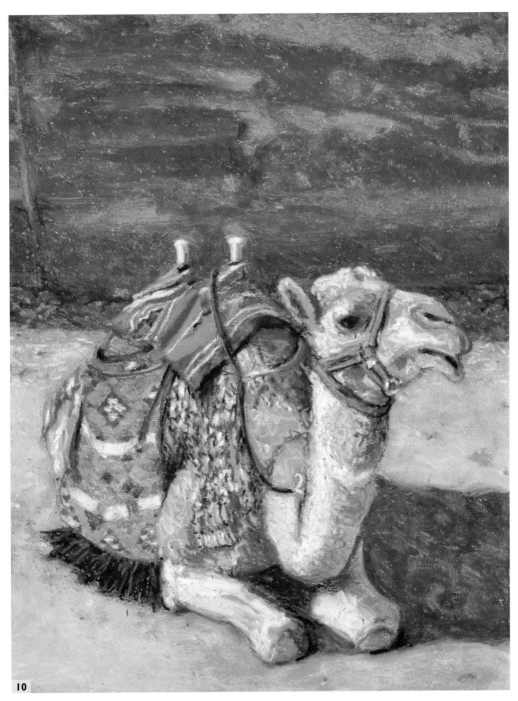

Step Ten I begin the final step by applying a light dusting of lemon yellow over the lights of the camel. Next, I layer with white, then pull and blend with good line work. This technique brings the camel to life. I use Vandyke brown and ultramarine blue to fix shadows throughout. Then I create definition and depth to the top blanket by adding orange for lights. I continually go back and forth on the Bedouin blanket, layering and correcting all colors used. With black, I finally push the darkest blacks to sharpen the image. I then add gray green to the metal number plate that sits in the crook of the camel's neck. Gray and white are both used as I continue working on the metal. As a final note, I remember to create the feeling of texture by varying my mark and blending method.

Pasadena Bridge

Having lived in Pasadena for many years, I've long admired the Colorado Street Bridge. A historic city landmark built in 1913, it has been portrayed by many artists. Capturing classic architectural beauty, history, and Old Town charm, the bridge spans the Arroyo Seco canyon. Basking in the warm glow of the California sun, it makes the perfect subject to draw.

With the Colorado Street Bridge as a focal point, I utilized perspective to create depth and movement through the piece. I recommend taking advantage of the point of view when creating a composition—this can greatly increase the overall dynamic impact of the finished work.

Color Palette

Matte medium; ultramarine blue acrylic paint

Oil pastels: Vandyke brown, yellow ocher, gray green, pale blue, cobalt blue, white, gray, deep green, yellow, Prussian blue

Step One The first step involves the creation of an accurate construction drawing. I exercised artistic license throughout the piece, omitting small architectural elements. Oil pastel is clumsy and thick, so I took my time to make strong shapes. As a result, this drawing served as my map through to completion. I used a heavier line weight to suggest shadow shapes, then sprayed a little workable fixative to help seal the drawing before the tone. I used gessoed rag paper for this drawing, and created a taped-off picture area that measured 11 by 17 inches.

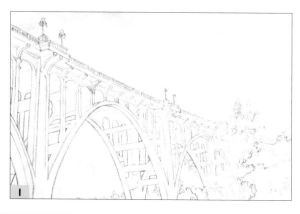

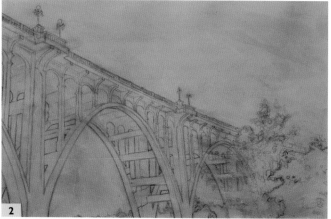

Step Two Now I toned the paper, using ultramarine blue acrylic paint mixed with matte medium. This process creates a transparent layer of color. The mixture was mostly made of matte medium and very little ultramarine blue acrylic paint. This also protects the drawing and seals it permanently.

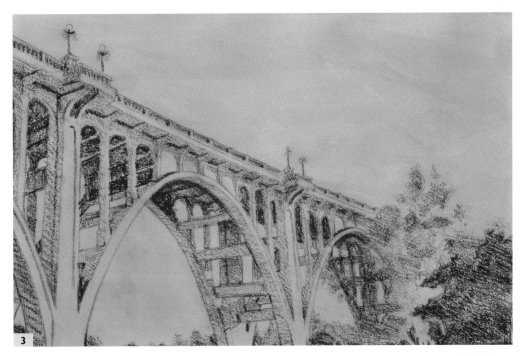

Step Three Next, I did a value study with Vandyke brown. It takes a lot of practice to create a delicate and detailed drawing with oil pastel. I layered the Vandyke brown to increase opacity for the darkest darks. Using a delicate touch, I drew in the lighter values.

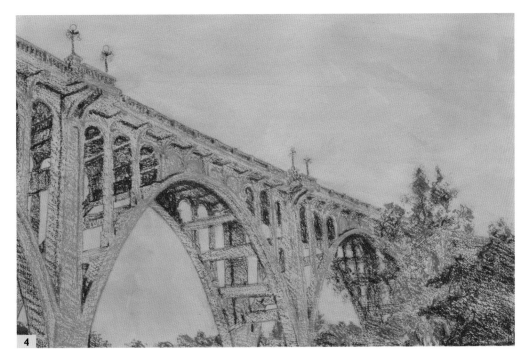

Step Four Using yellow ocher, I added the warm light on the bridge, watching the direction of my strokes to make a beautiful drawing. I also used this color to bring warmth into the tree trunks. Next, I created a layer of color, using gray green in the trees. I finished this step with a pass of Vandyke brown to adjust the value shapes.

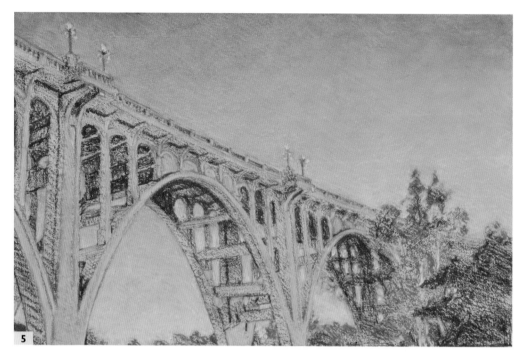

Step Five For the next step, I used pale blue and cobalt blue to crosshatch layers of color, then smudged with my fingers. As necessary, I used a kneaded eraser to pull out colors that got mixed in when smudging. Then I crosshatched layers of white, working the gradient from light to dark in the sky. Notice, the reference image gets bluer towards the top of the sky and whiter closer to the ground. I smudged again with my fingers to even out colors and then went back over with soft strokes. For the best effect, a combination of smudging and mark making should be used together. White was also used to lighten the bridge. Using gray, I drew the shadow side of the bridge lanterns, and then added white on the light side.

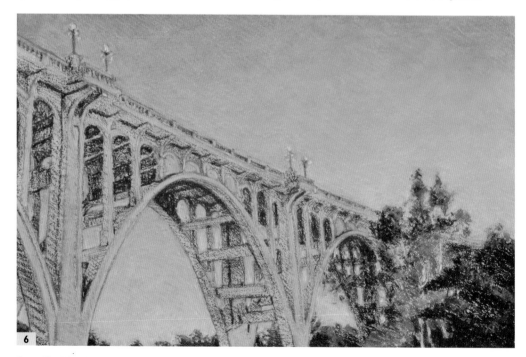

Step Six Next, I darkened the trees, using deep green. Yellow was used to brighten the light in the trees. Squinting helps me see the logical place to add light in my drawing.

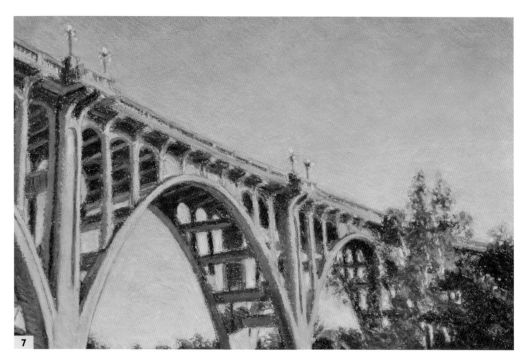

Step Seven In the final step, I used white, yellow ocher, deep green, Vandyke brown, and Prussian blue. I built opacity and thick oil pastel in the foreground, allowing it to be slightly thinner in the background to show perspective. Vandyke brown and Prussian blue were layered to create the darks. I continued working on the trees, punching holes in the leaves with the sky. Yellow ocher was the last step, used to bring the light into the bridge shadows. At this point, I did all the necessary touch-ups, using any color from this palette to fix inaccuracies.

Portrait

When drawing a portrait, I try to capture a pose that triggers emotion in the viewer. I find that subtle expressions can transcend the moment and provide a more lasting appeal than dramatic expressions, such as a smile. In this portrait, the unsmiling model glances down and away. To emphasize the introspective mood, I use a strong light source to create intense highlights and shadows. When setting up a portrait, experiment with various poses, expressions, angles, and lighting. It often is helpful to refer to the masters for compositional ideas. Vermeer's *Girl with a Pearl Earring* was my inspiration for this portrait.

Color Palette

Oil pastels: Black, brown, deep green, gray, green, green gray, lemon yellow, olive brown, orange, pale blue, pale orange, pink, Prussian blue, ultramarine blue, Vandyke brown, white, yellow ocher

Lighting the Model I used a single, strong light source when setting up the lighting for this reference photo. Placing the light at the right distance from the model will control the darkness of your shadow shape. A close distance allows for high contrast, while farther away creates a lower contrast. A solid background allows for only a gradient of light and shadow to be seen. This will keep the focal point on the portrait.

Step One I create a white border around the painting by taping the edges of the picture. Then I apply an even layer of acrylic gesso with a soft brush to the paper to increase its archival quality. After the gesso dries, I lightly sand away any brushmarks for a smooth surface. With an HB pencil, I transfer the portrait onto the gessoed paper, focusing on the planes of the face and the shadow shapes (see page 8 for more information on transferring an image).

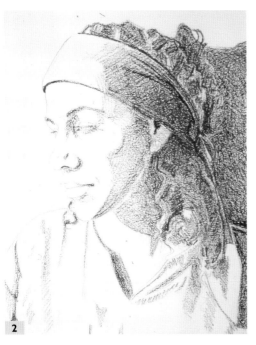

Step Two Now I start applying color by blocking in shadow shapes. Using Vandyke brown, I apply an even layer of tone over the hair, collar shadow, ear, and areas of the facial features. Then I push the darker shapes back further by layering more Vandyke brown. I use Prussian blue for the cast shadow in the background and the deepest shadows on the face, neck, and folds of the shirt. I apply deep green to the shadowed side of the scarf, using the sharp edge of the oil pastel to define the folds in the fabric. Then I layer Prussian blue over the Vandyke brown in the ear and collar shadow, pushing these darkest areas closer to black. I crosshatch strokes in light layers to ensure an even application of color.

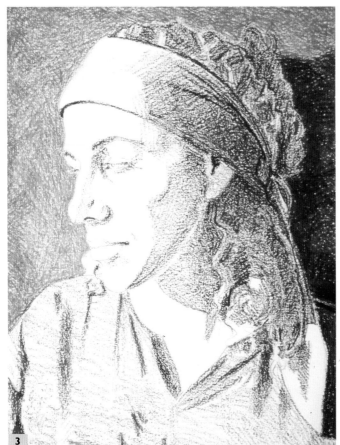

Step Three Next, I block in the background with an even layer of lemon yellow. Then I crosshatch green gray over the entire background, applying it on top of lemon yellow and the blue cast shadow of the head. I add another layer of Prussian blue near the hair to create a darker value. Then I lightly cover the shirt with green gray, applying heavier pressure to the shadowed folds.

29

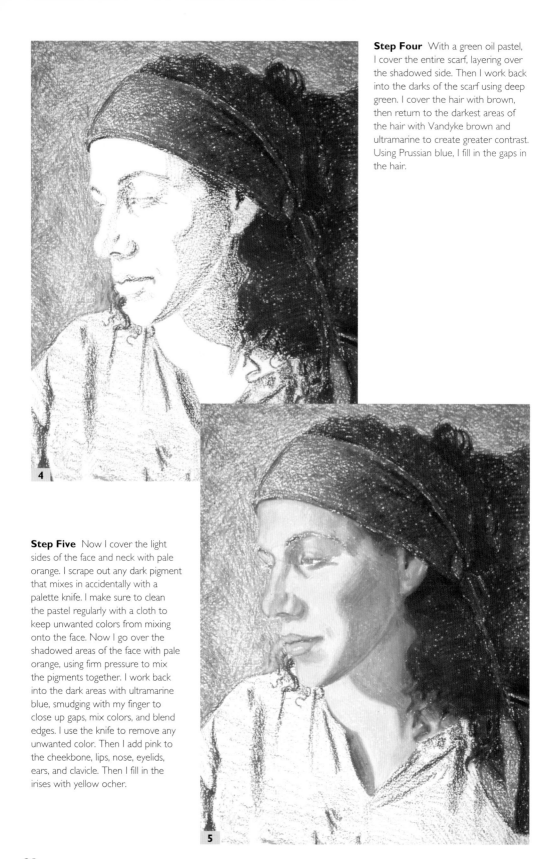

Step Four With a green oil pastel, I cover the entire scarf, layering over the shadowed side. Then I work back into the darks of the scarf using deep green. I cover the hair with brown, then return to the darkest areas of the hair with Vandyke brown and ultramarine to create greater contrast. Using Prussian blue, I fill in the gaps in the hair.

Step Five Now I cover the light sides of the face and neck with pale orange. I scrape out any dark pigment that mixes in accidentally with a palette knife. I make sure to clean the pastel regularly with a cloth to keep unwanted colors from mixing onto the face. Now I go over the shadowed areas of the face with pale orange, using firm pressure to mix the pigments together. I work back into the dark areas with ultramarine blue, smudging with my finger to close up gaps, mix colors, and blend edges. I use the knife to remove any unwanted color. Then I add pink to the cheekbone, lips, nose, eyelids, ears, and clavicle. Then I fill in the irises with yellow ocher.

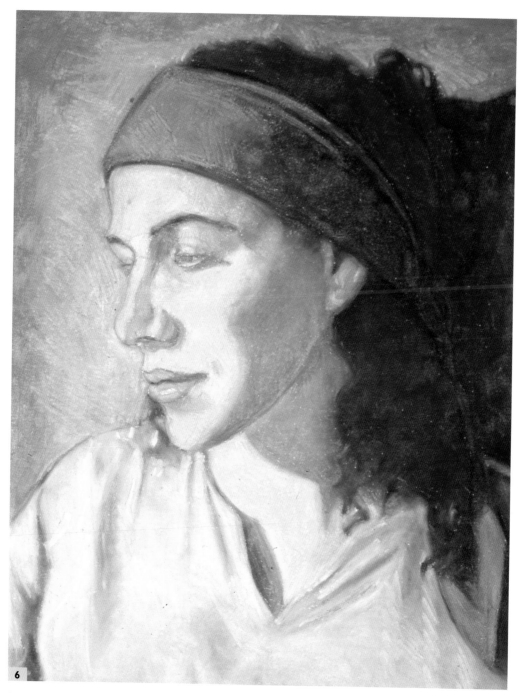

6

Step Six I go over the light areas of the shirt with white and blend the white and green gray with my finger. I also apply and blend white into the shadows and folds of the shirt. Using the smudging technique, I blend edges in the hair, shirt, and cast shadow of the head with my fingertips. I use the clean edge of the white pastel to define hard edges and wrinkles in the shirt, creating a variety of hard and soft edges. With gray, I crosshatch over the background and blend the pigments with my fingertip. I use the knife and scrape gently to lighten or remove pigment. Then I use white to create stronger light in the background, blending and scraping colors. Now I crosshatch over the lighter areas of the scarf with pale blue. I cover up any white showing through the pigment and soften edges throughout the drawing by smudging with my fingertip. Then I use a little olive brown to cover any white areas around the eye.

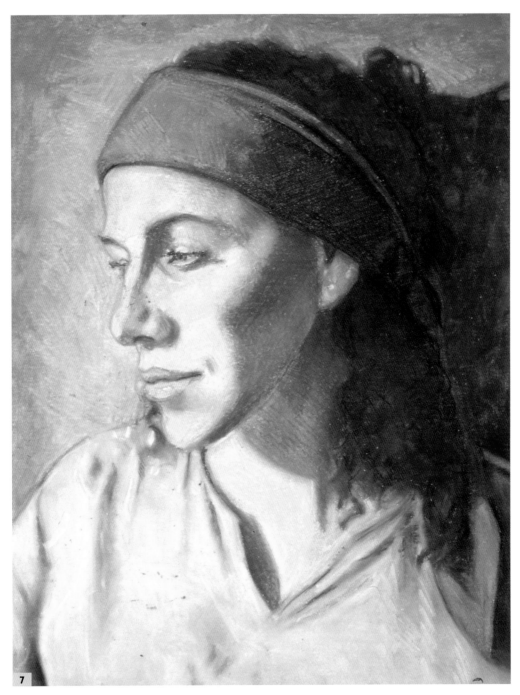

Step Seven Now I introduce more darks in the hair with Vandyke brown. Then I go in with black to suggest individual strands, blending them with my fingers. I neutralize the blue shadows on the face by lightly crosshatching brown and Vandyke brown over the pigment and blending various areas. I warm up the shadow edges with brown, then use black to accentuate the lashes and eyes. I delicately scratch and blend edges as I work, keeping in mind that this process requires both finesse and patience. I focus on the darks in the shirt using the least amount of black possible to sharpen some of the folds.

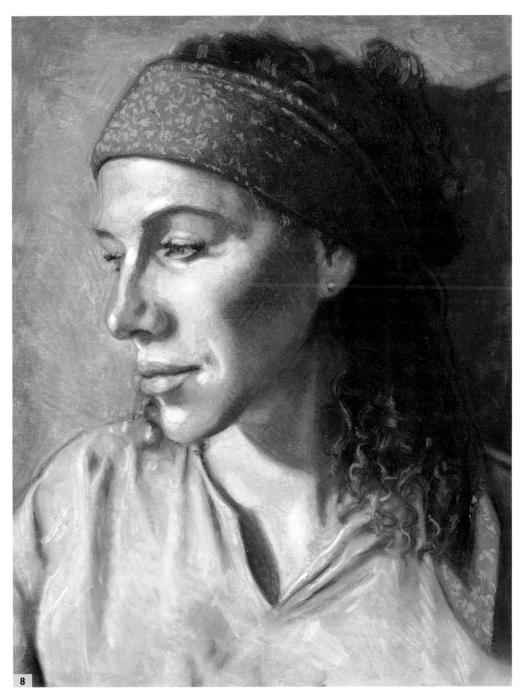

Step Eight Using black and Vandyke brown, I create more detail and push the darks even further. I apply Vandyke brown to the shadows on the scarf and face to neutralize them more. With the palette knife, I scratch and scrape out light areas in the face and hair, as well as create details on the scarf. Then I add some highlights in the hair and reflected light in the jaw's shadow with orange. Now I use white to create highlights in the face, accentuating the strong light source. In these final touches, I pay close attention to detail, scraping and blending my way to the finished piece.

Wooded Road

The beautiful dappled light drew me to this wooded road. The singular perspective of the road helps develop deep space. I've always loved the aesthetic of California's rolling hills and oaks, so this landscape made a perfect subject. Because of the many branches and small light and shadow shapes, it was important to make my working surface large to accommodate for the nature of drawing with oil pastel. This allowed more room for detail, gesture, and expressive mark making when I created the drawing. Variation in my marks, value, and color helped create emotion in the piece.

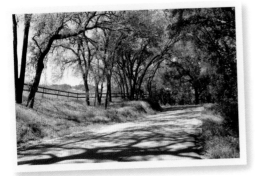

Color Palette

Matte medium; ultramarine blue acrylic paint

Oil pastels: Vandyke Brown, ultramarine blue, Prussian blue, gray, white, yellow ocher, deep green, olive brown, yellow green, green gray, lemon yellow, pale blue, yellow, black

Dappled Light This wooded road, laced with shadow, provided an excellent opportunity to study the contrast between cool shadow and warm light. The project also allowed me to capture and interpret light using impressionistic techniques.

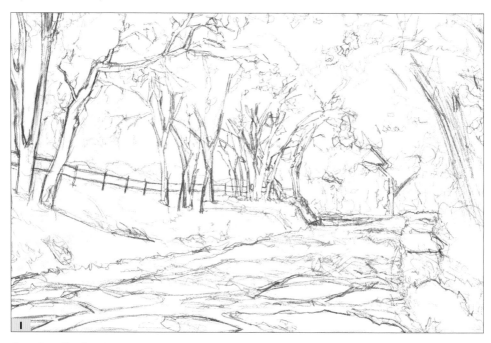

Step One First, I needed to establish an expressive and gestural drawing. To achieve this, I began by separating the major shapes of light and dark, figure, and ground. Variation in line weight was extremely important at this point.

34

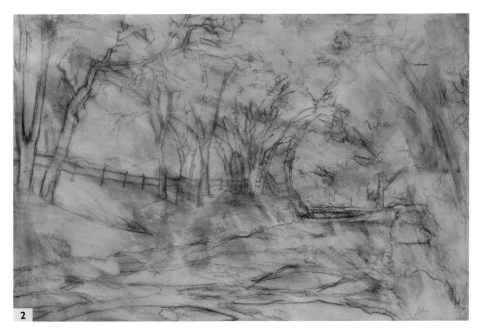

Step Two Next, I painted a transparent layer over the drawing, using matte medium and ultramarine blue acrylic paint. This process sealed the drawing, toned the image, and unified the colors. Ultramarine blue is a good color to use for landscapes as a base.

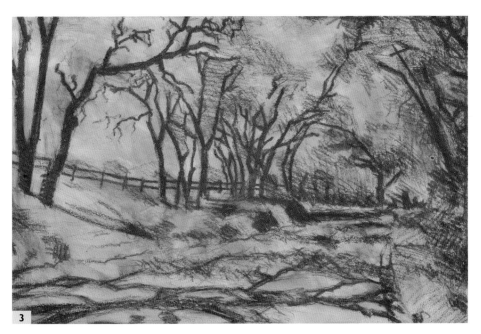

Step Three By squinting at the inspiration photo, I was able to locate the darkest darks. I then drew them in with Vandyke brown. I continued squinting as I began to separate the shadow shapes using ultramarine blue. Then I layered ultramarine blue on top of the Vandyke brown to create a darker color. I used a variety of marks, crosshatching, and gestural movements, always maintaining variation in line weight. At this point, the only oil pastel used on the foreground shadow shapes was ultramarine blue. I wanted to keep the shadows cool—that way, when I would later block in the light sections, they would be warm. As necessary, I used a kneaded eraser to correct my oil pastel application, always striving for proper shapes and line.

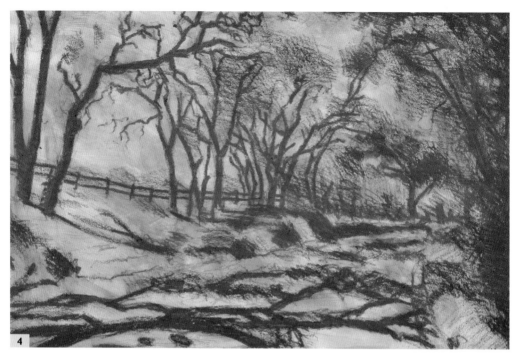

Step Four With Prussian blue, I kept working the darks and shadow shapes. As needed, I would go back in with Vandyke brown to correct and darken. I continued working the overall shadow shapes in the trees and on the ground, correcting the drawing as I proceeded.

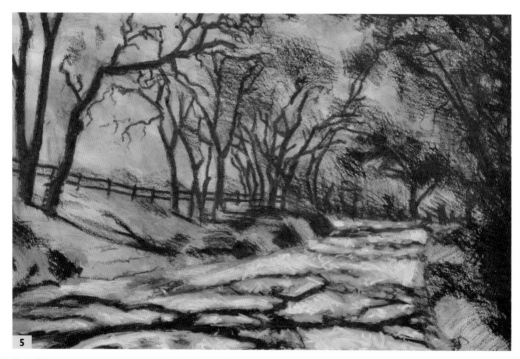

Step Five Using gray, I began to block in the light sections of the road. Then, I layered with white to brighten the lightest lights in the street. If necessary, I would blend slightly and remove excess oil pastel with my finger. After finishing the white in the road, I began working on the shoulder of the road. Here I used yellow ocher as a base, adding white over that.

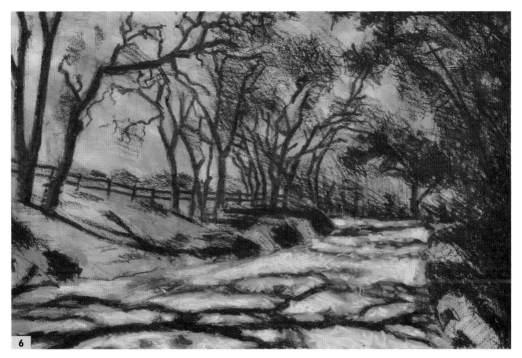

Step Six In this step, I adjusted the foreground branch shadows, making them a bit darker with Vandyke brown. Then, using deep green, I layered the darks in the trees, ground, mountains, and everywhere as needed. I continued to employ crosshatching and variation in line weight by alternately pushing harder, then softer, when making marks. Variation continued to be critical in value, mark, and color.

I layered the green and blended, using the pressure of my mark making. This created an even tone. Make sure to keep your crosshatching and directional marks uniform.

Notice the texture that can be created by the mark of an oil pastel. I used this to my advantage to increase the contrast of the shadow. The display of viscosity in this medium can be beautiful.

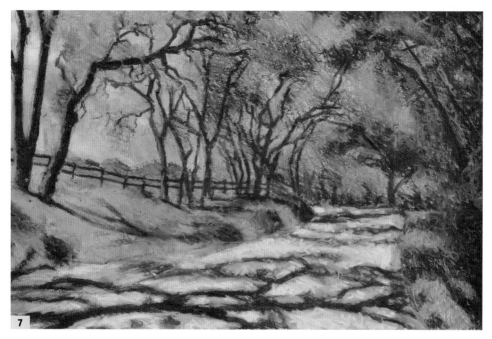

Step Seven Next, I added olive brown throughout the piece and started to work my way towards the lights. This created a transition between tones and was used for the dead branches and dry grass. Then I added yellow green in the grass, layering it to saturate the color. Finally, I moved into the trees using a gestural stroke that mimics trees and branches. This application was not as aggressive as the grass, more manic for variation.

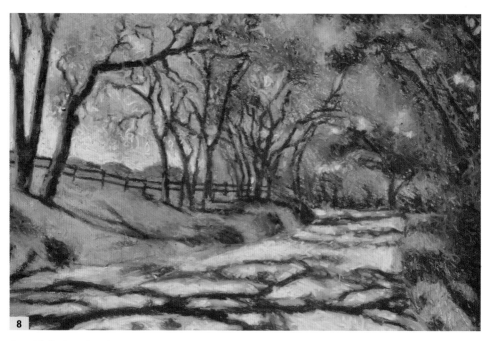

Step Eight I continued working the trees with green gray, yellow ocher, and lemon yellow. Then, I followed the light pattern and scratched away mistakes. At this point, I pressed hard to layer the oil pastel. Next, using a palette knife, I began to scrape away the oil pastel in the sky shapes in the trees. Then, I used pale blue to block in the sky shapes. It was important to remember that the blue is darker at the top of the image and gets lighter as it approaches the horizon line. To accomplish this, I applied white at the horizon line and transitioned to the pale blue. I then corrected the sky shapes using yellow green.

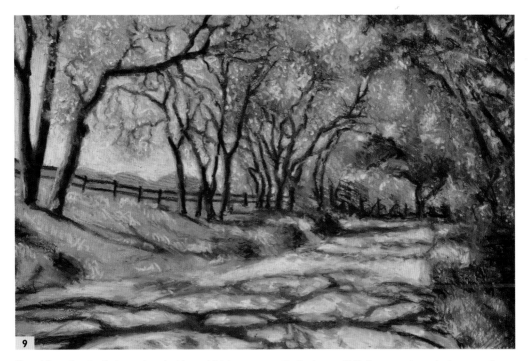

Step Nine For the final step, I used white and lightly went over the background hills for more atmospheric perspective. Then, with the palette knife, I scraped away oil pastel to increase the lights with yellow, yellow ocher, pale blue, and white. I made these marks by jabbing and pushing to create stippling, dots of light. Then, I cleaned up the tree darks with Prussian blue. I softened and worked the shadow shapes in the grass to make them more irregular. With Prussian blue and Vandyke brown, I softened the dappled light on the road. I used my finger to blend and soften edges, then used white to increase lights. Finally, I used black to solidify the darkest darks.

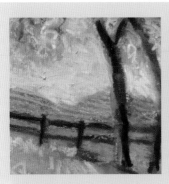

It's important to give your drawing an atmospheric perspective and a sense of space. Notice how a simple layer of white does the trick.

Influenced by Impressionism, the marks of color created the light in this section. These marks are similar to stippling—a practice of using dots in color or tonal application. I pressed hard and tried to mash chunks of color into the work, thus creating texture.

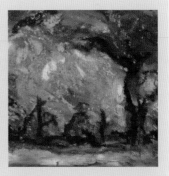

Capitalizing on the beauty of line and variation in line weight, the depths of the shadows were pushed with black. It's good to have variation in your line, combining hard edges with soft edges. This can be achieved by blending a selection of your lines with your finger to soften the hard edges.

Laundry Line

For an artist, finding inspiration in Venice, Italy, is like looking for sand on the beach. It's everywhere. When I saw this laundry line hanging from a building I felt compelled to draw or paint it. The quaint scene evoked a timeless connection with our past. The variety of textures and earth tones made a beautiful subject matter, especially when combined with the strong contrast in form and lighting. To capture the many details in this image—like the brick, the wrought iron and the shutters—I drew on top of the oil pastel after it had been laid down. Using a sharp tool, like a graphite pencil or Conte pencil, allowed me to scratch detail into an even layer of oil pastel.

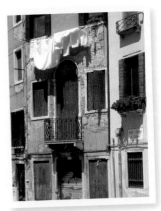

> **Color Palette**
>
> Matte medium; yellow ocher acrylic paint;
>
> Conte pencil in black
>
> Oil pastels: Vandyke brown, brown, deep green, Prussian blue, gray green, yellow green, gray, pale blue, yellow ocher, white, red, vermillion, lemon yellow, brown, purple

Using a Variety of Tools and Media For this project, I chose to use a variety of tools and media to create a particular affect. By employing the right tool, detail rendering can be easily achieved.

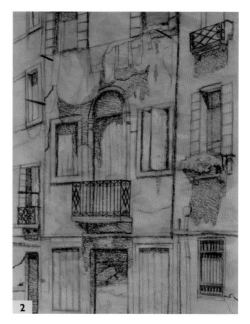

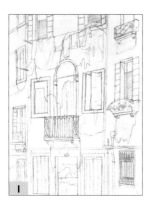

Step One Creating a strong drawing is always the best place to begin. This scene had much detail, so it gave me a solid base for my composition. I used line weight to suggest value and to separate shapes. Sometimes I place a sheet of paper under my drawing hand while I work, to prevent the movement of my hand from smearing the graphite. Workable fixative can also be used at this point to help control smudging. For this project, I used gessoed rag paper, Reeves® BFK, with a picture plane that measured 22 by 15 inches.

Step Two Next, I created a transparent mixture of yellow ocher acrylic paint and matte medium, and then brushed a layer of this over my drawing. This process both toned the paper and sealed the graphite. It's important to apply this carefully, without much brush work, or the drawing will be lost. I find it works best if I do a couple of layers. Then I grouped my darker values together using Vandyke brown. By varying the pressure of my marks, I was able to achieve darker darks—always striving for an even application of the oil pastel. As needed, I used a ruler to make straight lines. Since it is difficult to draw thin lines with oil pastel, I used a Conte pencil in black to draw the railings.

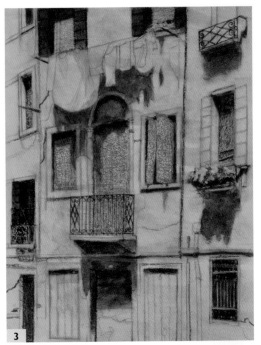

Step Three At this point, I covered the sienna doors with an even coat of brown. Then, using deep green, I focused on all the greens that were close in value, layering darks where appropriate. I added deep green on top of the Vandyke brown in the windows, as needed. Later I would separate the greens by layering other colors on top, and then smudging. For now, I lightly added a layer of Prussian blue over the shadows and darks. Then, using my finger, I smudged the oil pastels together, thus evening the tone. After smudging, I drew back in with the Prussian blue to recover the drawing. A kneaded eraser can correct smudging errors.

Step Four Next, I put a layer of Vandyke brown on top of the three center windows and blended accordingly. I then smudged, and followed this by drawing back into the doors with all the colors used thus far. I continued working shadows throughout, gradually replacing and smudging colors. Brown was added to the brick areas; Vandyke brown to the bars over the bottom right window. Finally, I worked on the metal door, smudging and drawing with Vandyke brown.

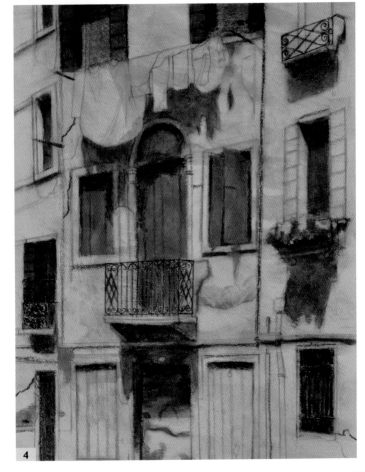

Step Five In this step, I filled in the two upper left windows with gray green, then smudged. Next, I added a layer of yellow green on top to create the light. As needed, I re-drew the railing with Conte pencil. I then used gray on the three bottom middle doors. At this point, I used only gray on the center door, but the two other bottom doors were smudged and layered with Vandyke brown, focusing on the darker areas of these doors.

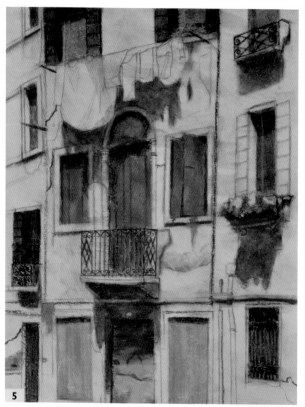

Step Six I then drew all the pipe with gray and smudged. I used gray green to draw the shutters on the window on the right, and then smudged. Using Prussian blue, I focused on details and darks. Then, I introduced a small amount of pale blue to the bottom doors. I added a little gray to the shadowed edge of the white window frames and the white arch around the center door. With yellow green, I touched up the barred window and any other areas needed. I also added a little gray on the window bars.

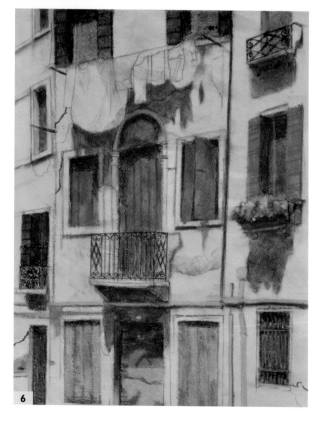

Step Seven Now I focused on the walls, using yellow ocher oil pastel lightly over them all. I then added a layer of gray to the stucco on the left, and blended. On the right, I added a layer of white and blended. I also worked on the lower portion of the image, on the casting shadow of the pipe, smudging the rail and window on the lower left.

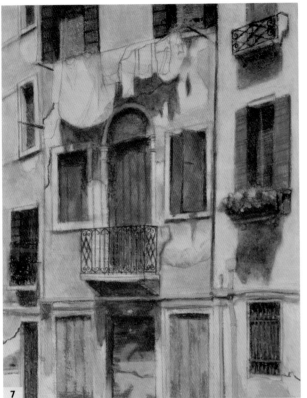

Step Eight This is the point where I brought in the white. All window frames were given a thick layer. The light sections of the laundry were also given a thick layer. For the white portions on the wall and the brick, I used a varied mark to simulate texture.

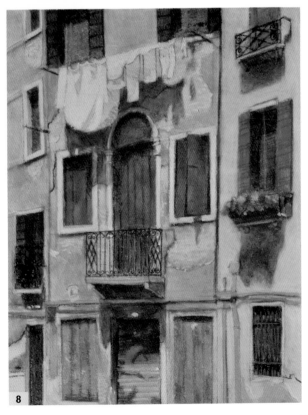

43

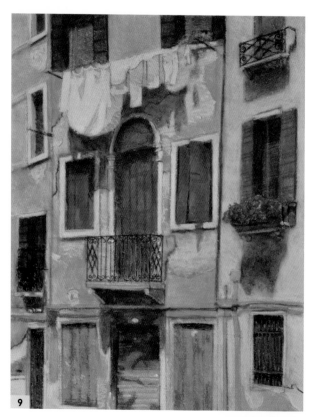

Step Nine For this step, I began by drawing the roses using red. Then, I added vermillion for the brightest reds. Then, using yellow green and lemon yellow I adjusted the color of the plants in the top window. With brown, I added more detail to the brown doors. I also used brown to color in the flowerpots.

Step Ten I drew the bricks delicately using the edge of the Vandyke brown oil pastel, keeping the line weight thin and light. Next, I used gray for the shadows in the hanging laundry. Then with Prussian blue and pale blue, I adjusted the laundry shadows to show the cool light. I added highlights on the window railings with yellow ocher oil pastel.

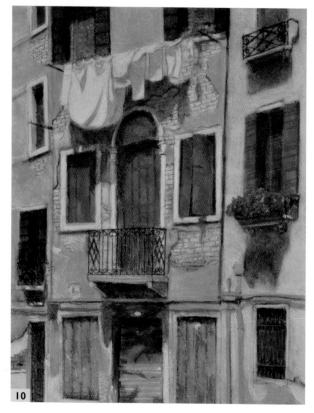

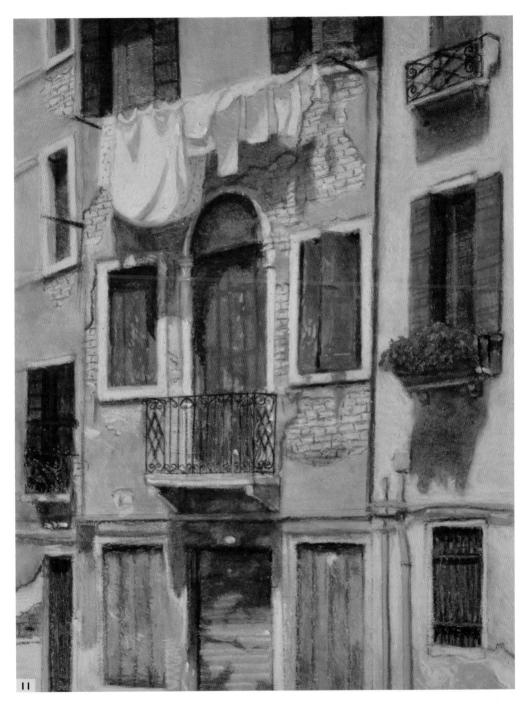

Step Eleven For the last step, I finalized the shadows using a little black, but this was done only in the darkest areas. I also lightly went over shadow shapes on the red doors to increase darkness. Yellow ocher oil pastel was used to warm up the light areas on the brown doors. It was important to create the appropriate contrast between light and dark on the brown doors. I added nicks with both gray and yellow ocher oil pastel to the doors and throughout the entire piece. With Vandyke brown, I added dots on the two pieces of laundry that were spotted. Stucco on the bottom right was adjusted with white. I made sure all pipes had casting shadows. Then, I walked away from the piece for awhile and came back to it later. This allowed me to see any mistakes or missed work. At this point, I added purple in the flowers in the upper window.

Perfume Bottles

I stumbled upon this beautiful still life in a perfume oil shop in Cairo, Egypt. The lighting and the delicacy of the bottles was so gorgeous, it was almost as if I had to draw it. It's perfectly acceptable to get your still life inspiration from someone else's placement and arrangement. As the artist, however, you must consider point of view and cropping as part of the process—there are many decisions to make along the way. To create the atmospheric perspective, I used a solvent and brushed over the thin layers of oil pastel. I placed the focal point on the foreground bottles, with the other bottles dissolving into the background. You can almost smell the sensuous bouquet when you look at this image taken in an exotic, distant land.

Enhancing Colors Transparent objects, like these bottles, can be tricky to draw, but this lesson will make the process easier. I'll also show how you can create a more striking piece by enhancing the colors. Note: It isn't always what we see, but rather, how we respond to what we see, that makes the difference in our artwork.

Step Two I prefer to create a common ground by toning my gessoed paper. For this, I used a transparent mixture of matte medium and burnt sienna acrylic paint. Using the matte medium both strengthened the piece and protected the drawing, so I could scrape away sections of the oil pastel as needed, without damaging the original piece. A couple thin layers works best. This mixtures dried fast and I was able to begin working with oil pastels soon afterward.

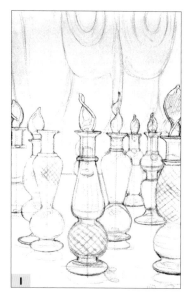

Step One It was essential, while creating the construction drawing, to have a center line on the bottles. This process ensures that both sides will be equal. Also when drawing the ellipses, I made a cross in the center, using a line perpendicular to the center line, thus creating a major and minor axis for the ellipse. This enabled me to judge the correct arch for each bottle. I then used variation in line weight as I slowly and accurately constructed my drawing. At this point, I sealed the drawing with workable fixative. For this project, I used gessoed rag paper, and taped off a picture area of 17 by 13 inches.

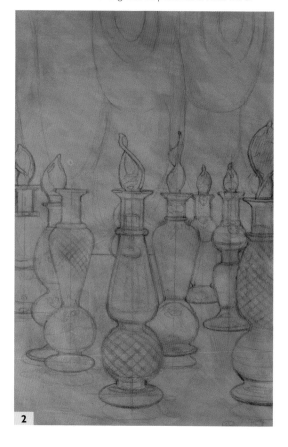

Step Three First, I added a thin layer of gray for the glass counter. Then, I layered white on top of that and blended them together with my finger. With Vandyke brown, I began defining the background shapes. I wanted to surround the figures/ bottle and separate them from the background.

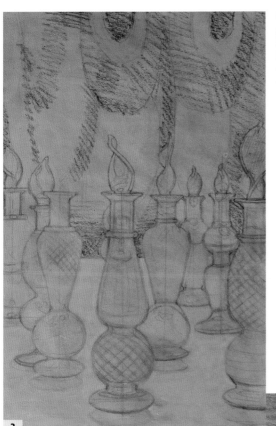

Step Four I continued using the Vandyke brown to define darks throughout. Then, I put a layer of olive brown across the entire background. I also added yellow ocher to certain areas and increased the saturation of Vandyke brown.

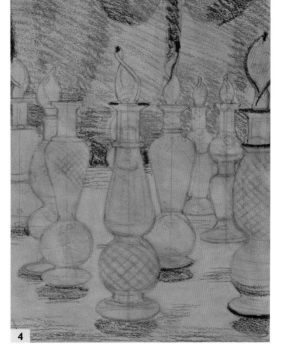

Color Palette

Matte medium; burnt sienna acrylic paint

Oil pastels: Gray, white, Vandyke brown, olive brown, yellow ocher, white, orange, lemon yellow, pink, pale blue, brown, Prussian blue

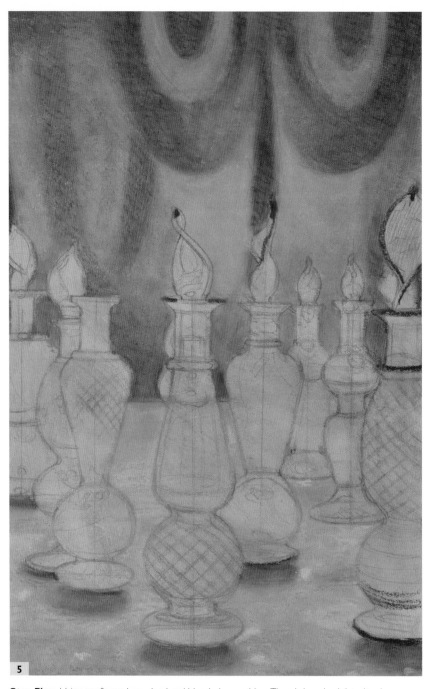

Step Five Using my finger, I smudged and blended everything. Then I drew back into it using Vandyke brown.

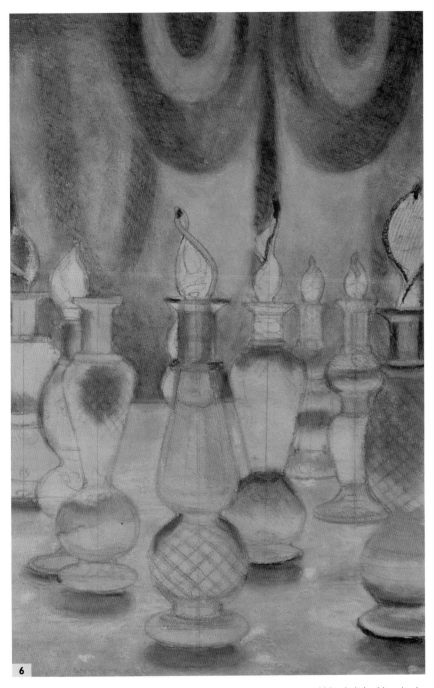

Step Six I added a thin layer of yellow ocher on the glass counter top and blended. At this point, I added white for the highlights.

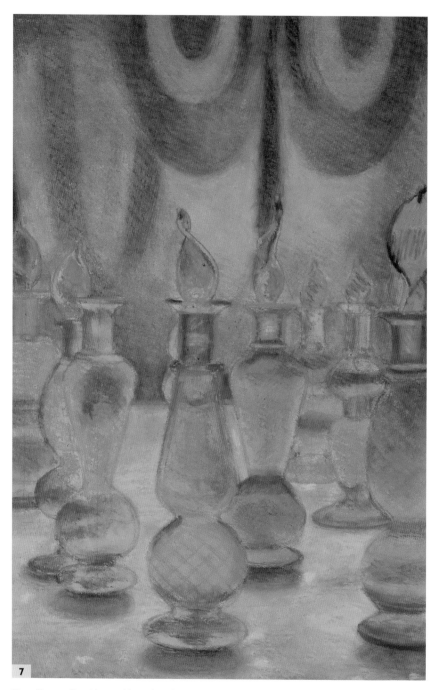

7

Step Seven For this step, I introduced orange, lemon yellow, and pink to the bottles, and followed this by smudging the colors. I also continued using Vandyke brown for the darks of the bottles. Next, I added gray in the glass bottles. Selected areas were accented with pale blue, and I used brown to darken the orange in areas. I worked with all the previously introduced colors to block in shapes.

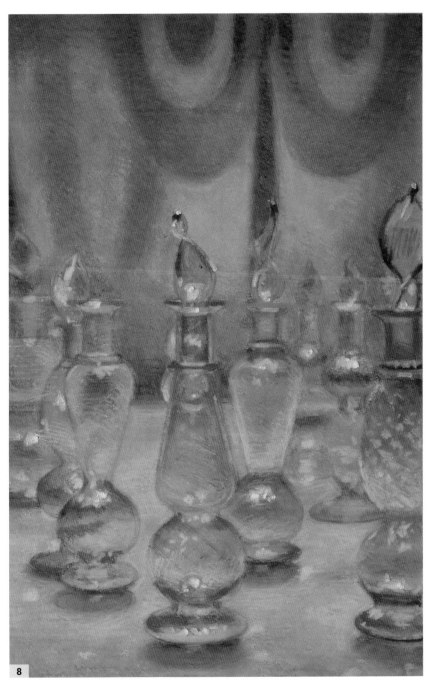

8

Step Eight Now I smudged everything and blended with my fingers. I used yellow ocher to help push the glass into the environment and cover-up unwanted pencil lines. I created darks with Vandyke brown, and then introduced Prussian blue for the darkest darks. Finally, I used white to create highlights. I pushed the white so hard that it crumbled and left a chunk on the paper. I also used light layers of white to make the bottles look transparent. Using yellow ocher, I made the background bottles recede and covered up any left-over graphite that might show through. Blending the background bottles helped them appear out-of-focus. I also smudged the background shapes and lightly covered them with yellow ocher. At this point, I used all the colors, touched up and rendered detail in the bottles, seeking a final atmospheric look.

Water Reflections

The attraction in this image resides in its abstract quality. While cruising down the Nile River in Egypt, I found myself surrounded by feluccas, small lateen-rigged sailboats. The complexity of form and color transformed this reference image into visual candy. The complexity made me slow down and get in touch with my intuition. This project reminded me how important it is to rely on my senses and be expressive. Feel it, be it, don't over analyze it.

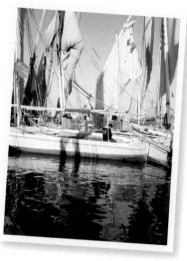

Working With Reflections This project offers the opportunity to learn how to portray reflections in water. Also, it shows how to make sense of complicated subject matter: editing confusing and unnecessary information.

Color Palette

Matte medium; ultramarine blue acrylic paint

Oil pastels: Pale blue, cobalt blue, white, ultramarine blue, olive brown, Vandyke brown, gray green, brown, orange, vermillion, Prussian blue, deep green, yellow, black

Step One I began by creating a construction drawing, building up slowly with a light line and then progressing towards a heavier line. I separated major masses and shapes, trying to make sense of all the information. It wasn't necessary to draw every rope, rather I focused on the major information that needed to be defined. I decided to edit some of the mess and confusion. The use of a little spray fixative helped the graphite from smearing. For this project, I used gessoed rag paper, and taped off a picture area of 14.5 by 11 inches.

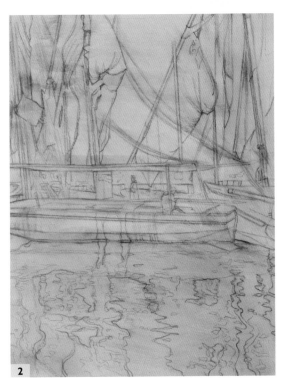

Step Two Landscapes and natural settings benefit from a base of ultramarine blue. So, I made a transparent mixture of ultramarine blue acrylic paint and matte medium to seal the drawing.

Step Three In this step, I wanted to start the process of separating the figure/ground relationship, separating the boats from the environment. Using pale blue, I blocked in the sky, and then using cobalt blue, I blocked in the blue of the water.

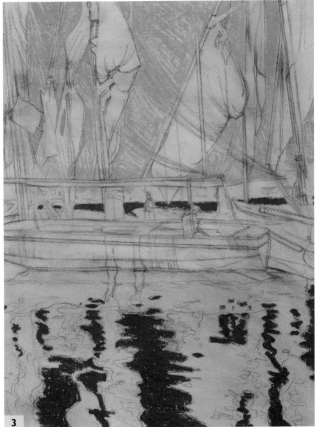

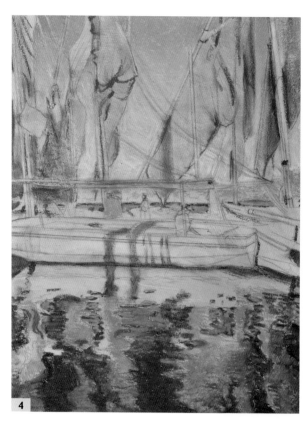

Step Four Next, I added white in the sky, starting a gradient from light to dark, from the bottom up. I brought the white into the water to adjust color. Then with ultramarine blue oil pastel, I darkened the top of the sky, smudging a bit with my fingers, leaving some of the marks. I also added ultramarine blue oil pastel to the bottom of the image to darken the water a little. Olive brown was added to the reflections and then smudged with my finger. Be careful not to accidentally make green by mixing colors. A little olive brown was added to the sails. Then with Vandyke brown, I started defining the darks. Finally, I used my fingers to smudge all the areas I just laid in, closing any gaps and making sure the paper didn't show through.

Step Five Using gray green, I added the foliage on the horizon line and smudged. Then, I mixed a little brown and olive brown for the hill in the far background. The pale blue line on the boat was added next. I used orange for the underside of the boat in the foreground. For the reflection, I used vermillion, gradating to orange as I worked away from the boat. Touches of vermillion and orange were then used throughout.

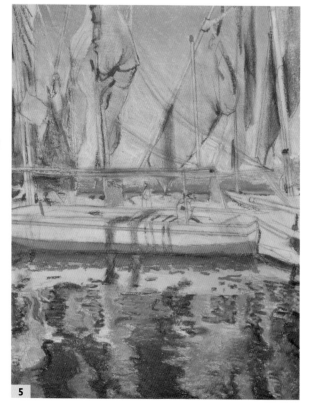

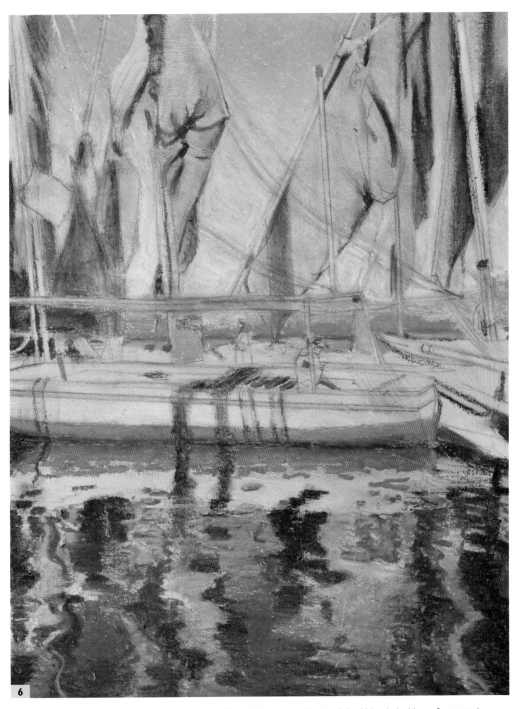

Step Six Prussian blue was used over most of the Vandyke brown and in the darks. I blended with my fingers and smudged away any gaps. Finally, I made corrections as necessary with the other colors already used.

Step Seven For this step, I added gray green for the flag. I continued adding darks that had been missed as I moved on with Prussian blue and Vandyke brown. Little touches and details of deep green were added around the piece. I worked on the reflections in the water, first with white, then olive brown, and pale blue. I layered colors, blending, going back and forth, varying the colors. The white was heavily layered and used to lighten colors that had gradations of value.

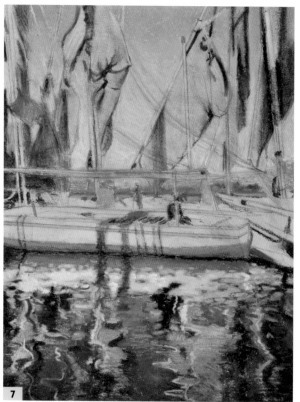

Step Eight I continued working on the reflections. With white, I started in on the boats and sails. Brown added color to the middle of the boat. Next, with delicate care, I began to build the light on the sails, adding ropes with Vandyke brown and alternating with white, as I followed the value patterns. Yellow was added to the bottom of the foreground boat; I placed it next to the white, just a little for the glow. Also, yellow was used on the few ropes and poles that had that color.

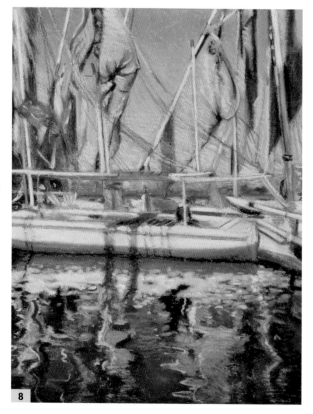

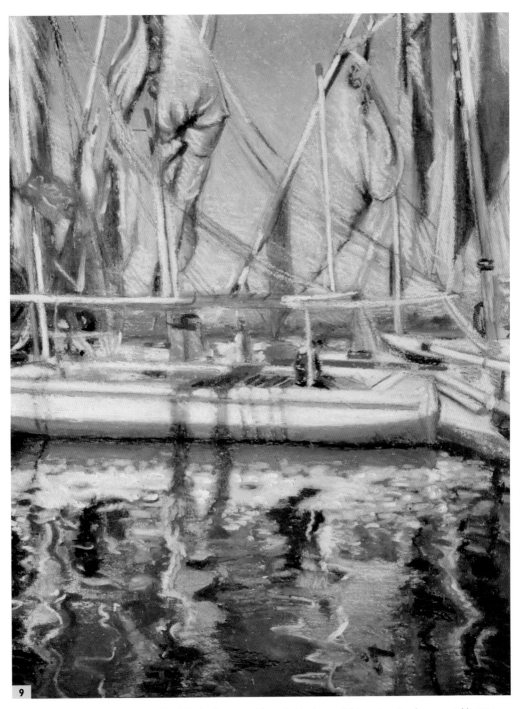

Step Nine In the last step, I added black in the foreground. I needed to be careful, to not go too heavy, watching my marks, making them look good. Then, I danced through the piece, looking for little details and corrections. I pumped up the opacity and thickness of the colors, adding little specifics like ropes, small shadow shapes, and smaller details.

Gondola

When I took a trip to Venice, I hoped to capture and convey the feeling of solitude and romance. It took some searching, but I finally found the perfect moment of history, beauty, and silence. Except for the water lapping against the bricks and foundation of the ancient city, everything was still and serene. The strong contrast and textural diversity worked together to make this moment magical and give this image strength.

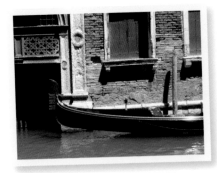

Creating A Compositional Study For this project, I focused on the Venetian gondola as a compositional study. I utilized the space division based on the Golden Section—an approximate ratio of 0.618 to 1.000—and placed the center of the two columns so they would intersect with the front of the gondola at the critical point. Throughout history many artists have used this approach to composition.

Color Palette

Matte medium; burnt sienna acrylic paint

Oil pastels: Vandyke brown, Prussian blue, green gray, black, gray, olive gray, yellow, brown, ultramarine blue, deep green, orange, white, olive brown

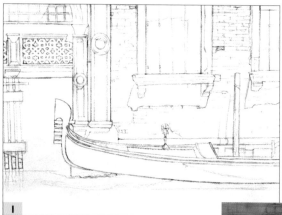

Step One I began with my construction drawing. This can be sealed with fixative if you wish, a process that will help prevent the oil pastels from smudging. For this project, I used gessoed rag paper, with a taped off picture area that measured 13 by 17.5 inches.

Step Two I toned my drawing and paper with a transparent mixture of matte medium and burnt sienna acrylic paint. Make sure to do this in a few layers, rather than just one, and concentrate some color on the bricks. This will make the brick wall easier to do later.

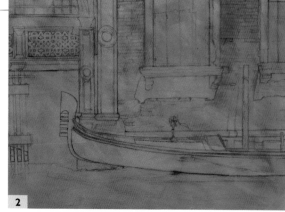

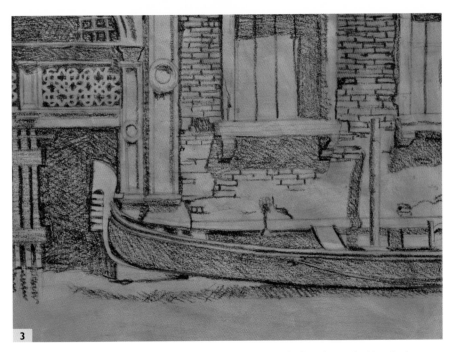

Step Three Using Vandyke brown, I grouped and separated the shadow shapes. At this point, it was important to strive for even tone and to layer my marks with crosshatching. I also blocked in the darks.

Step Four At this step, I added Prussian blue over the shadow shapes and blended with my finger. With green gray, I colored in the water and smudged with my fingers. Then I was able to crosshatch over the shadows that were cast upon the water.

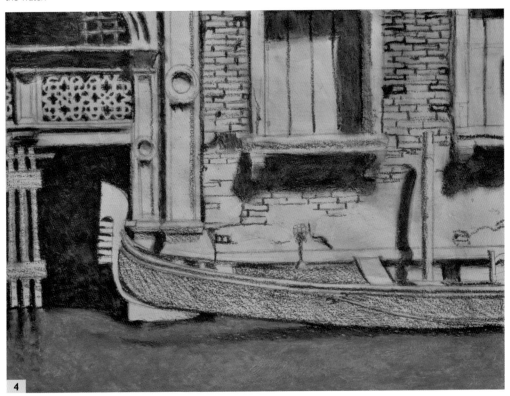

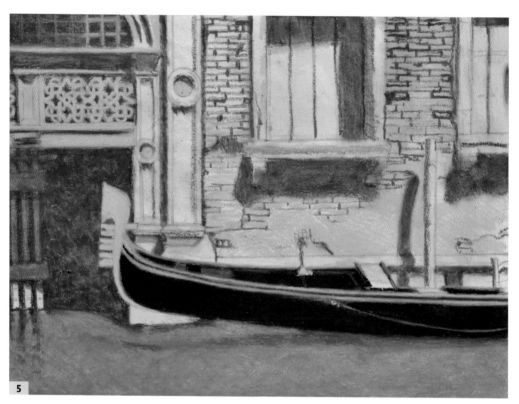

Step Five Using a lot of pressure, I liberally layered black on the gondola until I could smudge the thick oil pastel. Then with gray, I made my way through the piece, addressing parts of the gondola and smudging with my fingers. Next, I continued up the wall, using a kneaded eraser to correct mistakes. I scraped with a palette knife to remove any unwanted pigment. I pushed the gate back with a smudged layer of Vandyke brown.

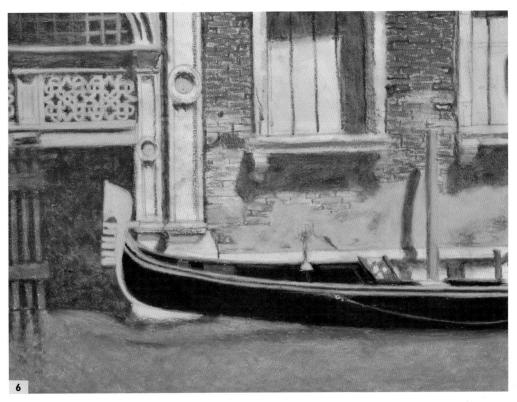

6

Step Six In this step, I layered olive gray on top of the cement sections of the wall and the post, then blended with gray using my fingers. I added a little yellow for the gold trim on the gondola, the vase, and in the post. With brown, I began to focus on the bricks, using a heavier saturation at the top and gradually decreasing toward the bottom, where the color is more neutral. I blended in selected areas with my finger, but left a lot of the image rough.

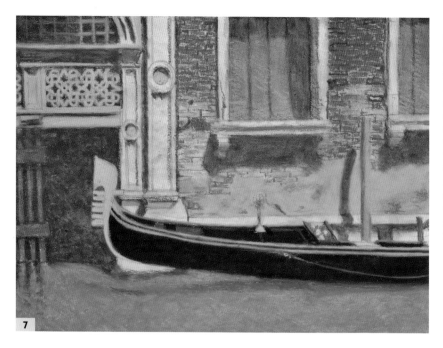

7

Step Eight Here, I started by adding a little deep green for the base of the flowers, then orange for the flowers themselves. I also used orange on the gondola handle. White and ultramarine blue were used to bring form to the water. Next, I blasted white throughout the drawing—a fun part of the process. I carefully layered marks, creating opacity on the gondola, the wall, and throughout the drawing.

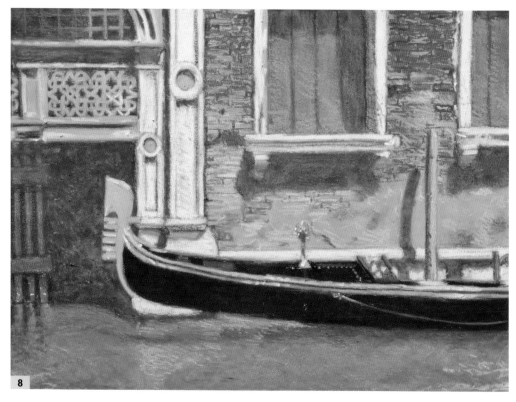

8

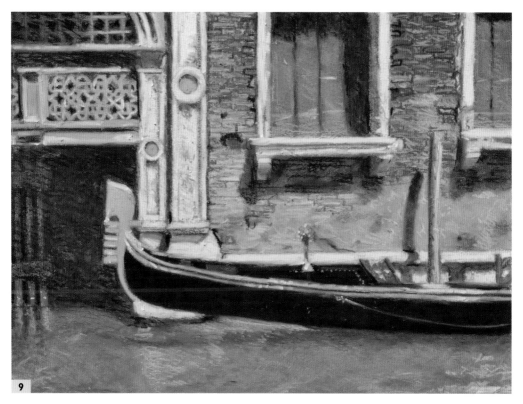

Step Nine Finally, with olive brown, I added some warmth into the top of the bricks. Using black, I focused on the dark sections and the cracks. At this point, I made my final corrections with all the colors used thus far.

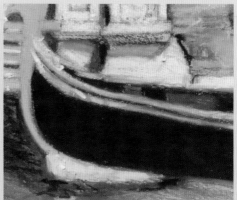

Notice how the olive brown and white created a lighter value from the color of the bricks underneath. This increased the appearance of the directional light coming from above. Strong light patterns create form and depth in observational art.

In this detail you can clearly see how adding black into your darkest darks will increase form. This is used to clarify your drawing, to add detail, and to show the true contrast of the sunlight. Always strive for elegant mark making.

Closing Words

Writing and executing the projects for this book was an absolute pleasure. By immersing myself in oil pastel, I furthered my love, knowledge, and understanding of this medium, and I hope this book will help you in the same way. The immediacy of drawing and the saturation of painting available in oil pastel has proven it is strong, bold, and expressive. You have the option to render by taming this medium, or you can embrace its expressive nature and inconsistent mark making. Go forth and make art!

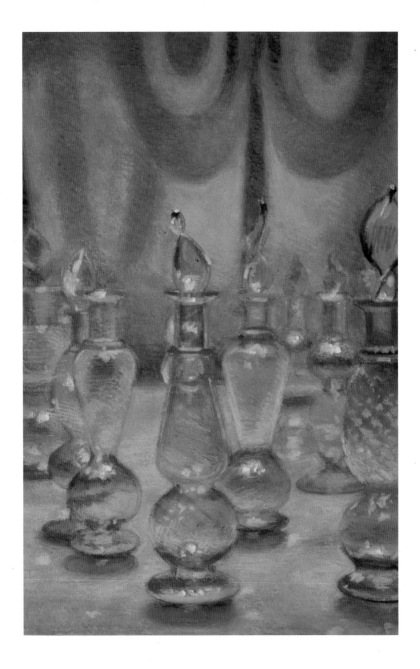